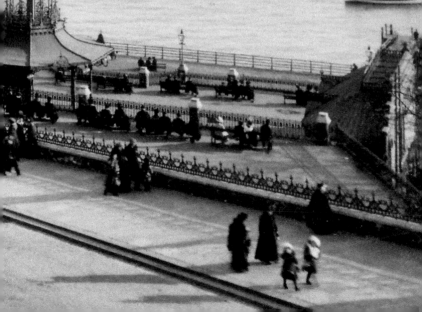

SOUTHEND
HISTORY TOUR

ACKNOWLEDGEMENTS

All black and white photographs (except on pages 46 and 47) were sourced from Footsteps (www.footstepsphotos.co.uk). All colour photographs and the black and white photograph spanning pages 46 and 47 were taken by the author.

This book is based on *Southend Through Time* by the same author.

First published 2018

Amberley Publishing
The Hill, Stroud,
Gloucestershire, GL5 4EP
www.amberley-books.com

Copyright © David C. Rayment, 2018
Map contains Ordnance Survey data
© Crown copyright and database right
[2018]

The right of David C. Rayment to be identified as the Author of this work has been asserted in accordance with the Copyrights, Designs and Patents Act 1988.

ISBN 978 1 4456 7989 1 (print)
ISBN 978 1 4456 7990 7 (ebook)

British Library Cataloguing in Publication Data.
A catalogue record for this book is available from the British Library.

Origination by Amberley Publishing.
Printed in Great Britain.

CONTENTS

PREFACE

Although *Southend History Tour* uses a few previously unpublished photographs, it is in many ways an abridged version of my successful book *Southend Through Time*. Many of the pictures used in that book have been used here, but in the main part without the juxtaposition of historic and contemporary photographs. In this miniature book I have partly rewritten the text to include information that space in the *Through Time* format would not allow. Thus, *Southend History Tour* may be read as a book in its own right, or it may be seen to be an easily transportable pocket-sized companion guide to *Southend Through Time,* complete with a map pinpointing places of interest, so enhancing the readers experience whether the reader be a day tripper, a long-term tourist or a Southend resident.

The tour begins at Prittlewell Priory and on leaving that place of much historic interest we travel south along Victoria Avenue towards the seafront, via the high street. After visiting the seafront we switch to Shoebury on the east side of the borough and then on to Leigh-on-Sea on the west side. In that sense this book may be seen to be divided into three sections, with a map before each section. The reader may consider beginning in North Shoebury and moving through to Leigh-on-Sea, or vice versa. Wherever you choose to start the tour will probably be determined by your mode of transport.

Southend is a large borough and you do not have to complete the tour in a single day. Please be advised that Prittlewell Priory is only open during the summer months and Prittlewell railway station is closed on Sundays. Southend Museum is also closed on Sundays, as well as Mondays. Opening times can change, so do check before you visit.

David C. Rayment

INTRODUCTION

Before the late eighteenth century Southend was a small hamlet of little significance at the south end of the parish of Prittlewell. It was basically farmland and woodland with a small fishing village at its southern extremity. Prittlewell, however, had long been established, having once been a thriving Saxon settlement. In 2003 archaeologists discovered a high-status burial there, the inhabitant of the grave now referred to as the 'Prittlewell Prince'. Prittlewell also has its own priory, which was built around 900 years ago.

Much of the building complex was destroyed in the mid- to late 1530s at the time of the Dissolution of the Monasteries by Henry VIII. That which remains has been allocated a Grade I listing.

In later years most of the trade at Prittlewell was carried out south of the priory and near the parish church dedicated to St Mary the Virgin, namely North Street and East Street.

In the 1790s, however, properties began to be built on the clifftop overlooking the sea and one of the first of these is today known as Royal Terrace. Princess Caroline of Wales stayed there, as did Lord Nelson's mistress, Lady Hamilton. They enjoyed the bathing, probably using the bathing machines owned by Edward Myall the Elder who, after his death in 1819, bequeathed the machines to his wife, Elizabeth. Mrs Glasscock also operated in the area at the same time and may also have accommodated such distinguished individuals. There was also Ingram's Baths at the foot of Pier Hill from 1804.

Further properties began to be built in Southend and by 1842 it had its own parish church dedicated to St John the Baptist. Even so, on 28 August that year Queen Victoria, when sailing down the River Thames on board the *Royal George,* wrote in her journal, 'At 11 we passed a small Watering Place called Southend...', indicating Southend had grown sufficiently to be recognised as a place in its own right but still a place of small size.

The catalyst for further growth was the coming of the railway from London stations. First, it was the opening of the line from Fenchurch Street to Southend Central Station, which is near the centre of the High Street but at its north end as it was then. Street numbers ran from north to south instead of south to north as they do today. No. 1 High Street, on the east side, was the London Hotel, with a thatched cottage opposite on the west side, at the corner of Clifftown Road. Second was the opening of the line from Liverpool Street to Southend Victoria Station, which is just past the north end of the High Street as it is now. New properties were built, mainly on the west side, on land once held by Daniel Robert Scratton, lord of the manor of Prittlewell, who moved to Devon.

Southend grew in stature as a tourist resort in the twentieth century, given its easy access to day trippers from the London boroughs. It is now home to well-known stores such as Marks & Spencer and Sainsbury's. Essex University also has a presence in the town.

In the future, like the past, buildings will come and go. In, say, 100 years, people will look back and remember those buildings that were, or they will marvel at the longevity of those buildings that still exist.

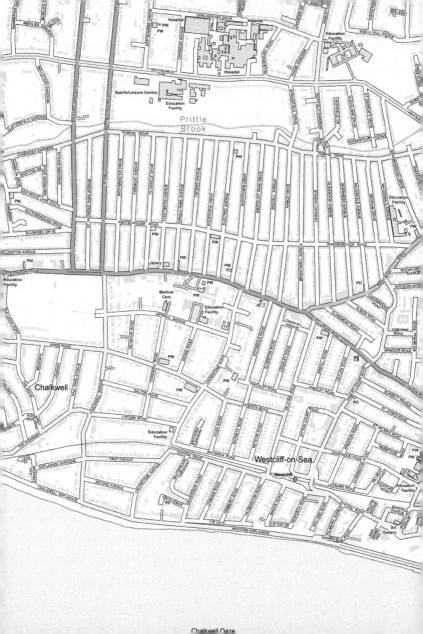

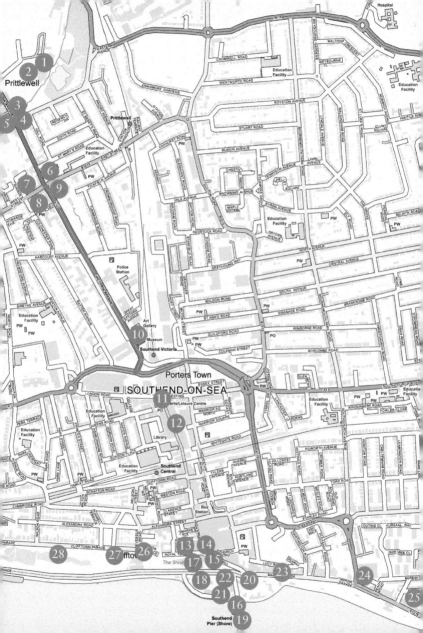

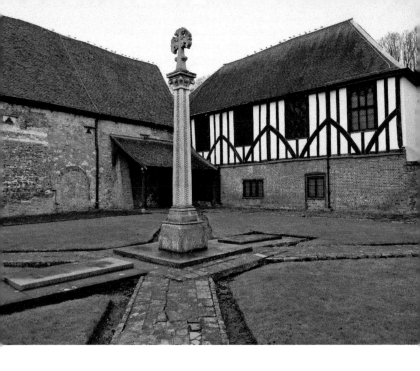

1. PRITTLEWELL PRIORY

Prittlewell Priory was founded in the first part of the twelfth century and dedicated to the Virgin Mary by Robert FitzSwein. It was passed to the Priory of St Pancras Lewes and became one of eight priories in England to be governed by that order. St Pancras Lewes was itself governed by the Abbey of Cluny at Burgundy. There are two fish ponds on the south side of the Priory Park which the Cluniac monks used and these are still fished today by visiting anglers.

In 1678 the priory was purchased by Daniel Scratton. It remained in the Scratton family for nearly 200 hundred years. The property was put up for sale in 1869 when Daniel Robert Scratton moved to Devon and bought an estate there. The priory was acquired by John Burness of Leytonstone. Burness sold the property on to Williaim Keys (later of Southchurch Hall), who, in 1874, sold it to John Farley Leith QC, one-time MP for Aberdeen. Leith died in 1887 and the property was purchased by William Howell Scratton. R. A. Jones bought the priory and the surrounding land in 1917. He presented it to the council for the use of the people of Southend.

2. WATER FOUNTAIN

Robert Arthur Jones also presented this water fountain, which stands in Priory Park as a First World War memorial, to the borough of Southend. Note the dates: 1914–1919. This takes into account those who died of their wounds after the war ended.

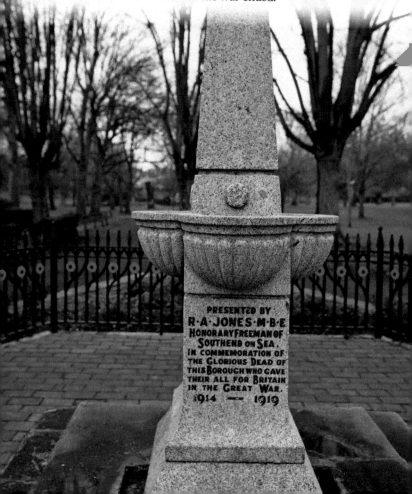

PRESENTED BY
R·A·JONES·M·B·E·
HONORARY FREEMAN OF
SOUTHEND ON SEA.
IN COMMEMORATION OF
THE GLORIOUS DEAD OF
THIS BOROUGH WHO GAVE
THEIR ALL FOR BRITAIN
IN THE GREAT WAR.
1914 ⎯ 1919

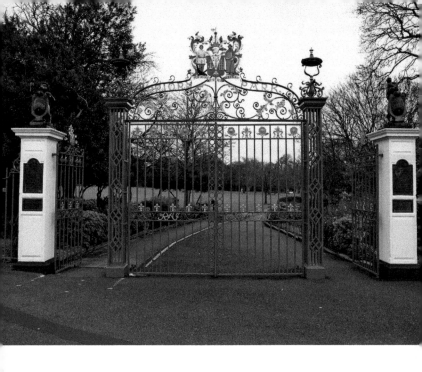

3. PRIORY PARK GATES

The left and right columns of the Priory Park gates each carry a plaque to commemorate R. A. Jones, who gave the park to the people.

Southend borough's civic arms sit on top of the gate, which, when translated from the Latin, reads 'By sea, by church'.

ABOUT R. A. JONES

Robert Arthur Jones was born in Everton, Liverpool, on 20 November 1849 and was baptized there on 1 September 1850 at the Church of St Augustine, which was attached to the parish of Walton-on-the-Hill. He married Emma Julia Pedley at Stoke-on-Trent parish church on 2 February 1878. At Southend he was a watchmaker, jeweller and optician, trading from the Pier Pavilion and from premises at Nos 76–78 High Street. The business that carried his name closed in the 1970s, but the High Street building from which he traded still stands, even though the site suffered some bomb damage during the Second World War. It is currently occupied by Yours – a fashion retailer for women. Robert's father, John Jones (formerly of Flintshire, Wales), was a watchmaker, as was his father, Edward. Robert's mother's father, however, was a flour dealer. Robert Arthur Jones MBE, an Honorary Freeman of Southend-on-Sea, died in Southend on 23 May 1925. His generosity is remembered by the park and the several inscriptions that carry his name throughout the borough of Southend.

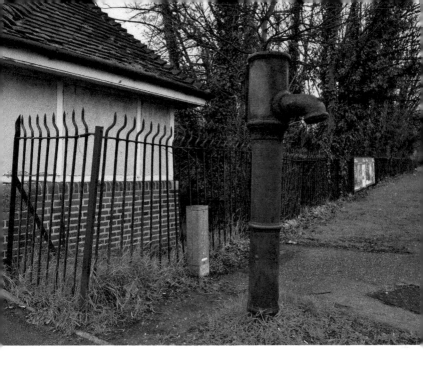

4. WATER PUMP

Near the Priory Park gates is this old disused water pump, which stands at the corner of the south side of Priory Crescent (the north side is now the A1159) and Victoria Avenue. It is a later installation than the pump shown in the picture on the following two pages.

5. PRITTLEWELL VILLAGE

This is a view of the old Prittlewell village *c.* 1905 at the bottom of Prittlewell Hill, looking north. The bridge that crosses Prittle Brook can be seen on the left. Prittle Brook joins the River Roach at Rochford, which then separates Wallasea Island from Foulness Island as it joins the River Crouch between Burnham-on-Crouch and the North Sea. The cottages have long been demolished and once stood around where the gates to Priory Park stand today. Also note the water pump on the right, which predates the one shown on page 15.

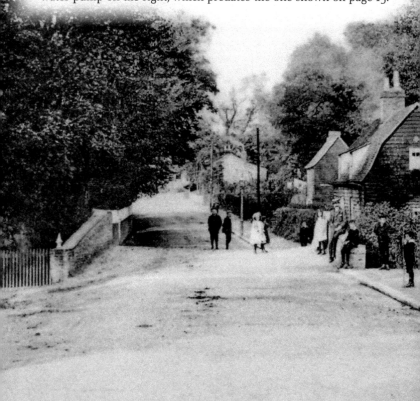

6. ST MARY'S CHURCH

This is the parish church of Prittlewell (*c.* 1925), which is dedicated to St Mary the Virgin. It sits at the top of the hill overlooking the old village and priory. Several of the Strachan family are interred here, while others at Broomfield, Chelmsford. The railings no longer exist, having been replaced by a wall.

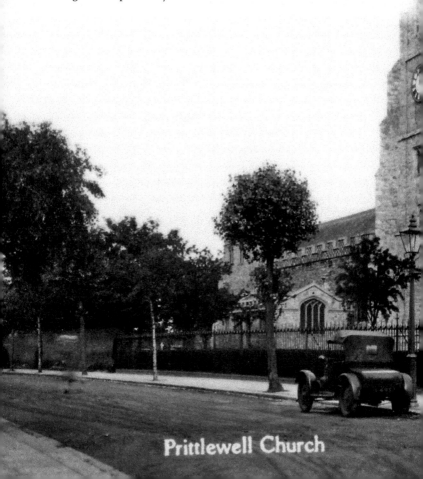

Prittlewell Church

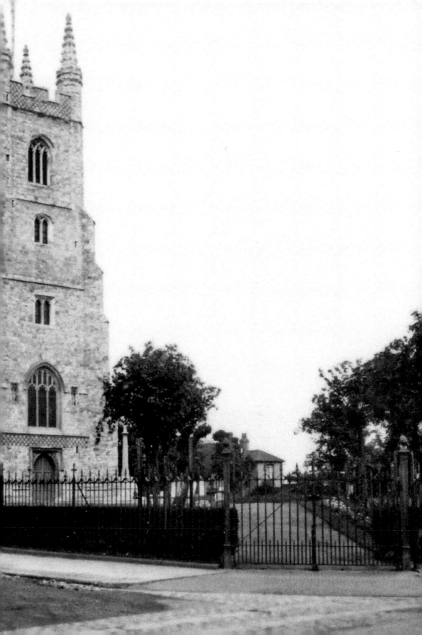

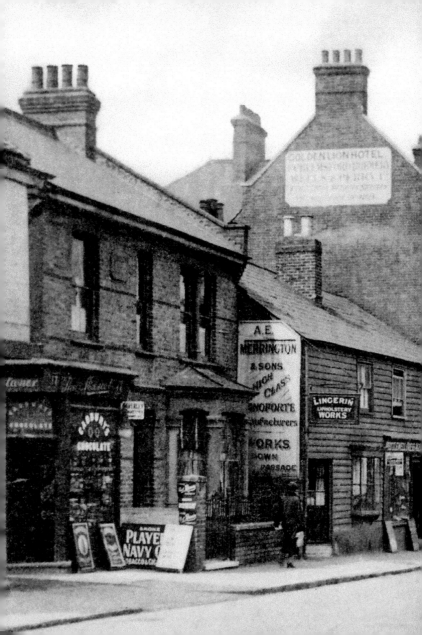

7. GOLDEN LION HOTEL

The church railings can be seen on the right. The tallest building on the left is the Golden Lion Hotel, which still stands today. It had a lucky escape in the late nineteenth century when a brick building at the back of the hotel was struck by lightning in 1888. The building on the south side of the Golden Lion was occupied by Prittlewell Press Agency and in the early 1920s the lingering upholstery works was occupied by George Charles Boniston, later of West Street, Westcliff.

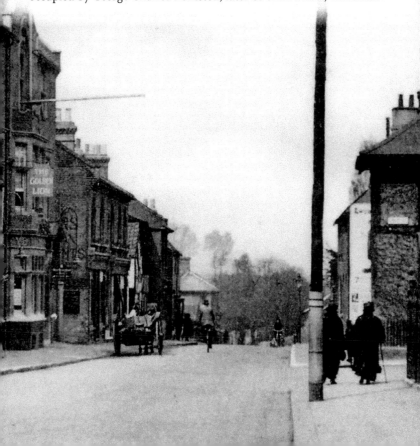

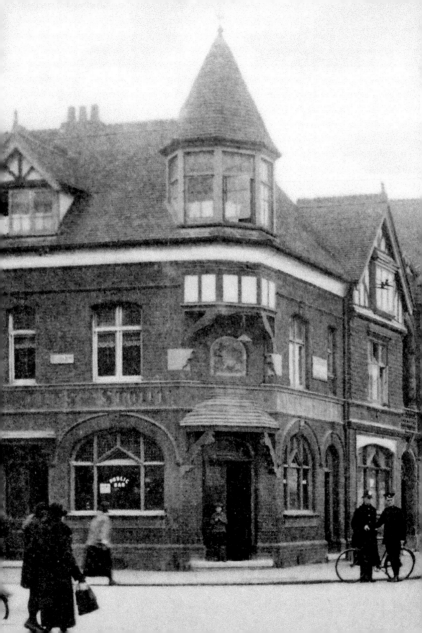

8. BLUE BOAR

The Blue Boar is a pubic house situated on the corner of Victoria Avenue and West Street. Southend United Football Club was founded here in 1906. One of the directors was Oliver Trigg, licensed victualler of the Blue Boar. Players were signed in July, as was the manager, Robert Jack, formerly of Plymouth Argyle. A blue plaque commemorating the founding of the club can today be seen on the east-facing wall. In the same year a Tudor fireplace was found in an adjoining building and was sold to Kensington Museum.

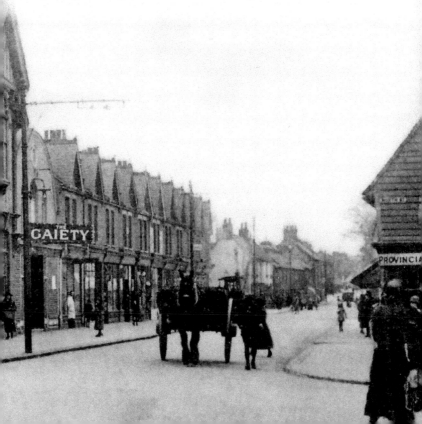

9. EAST STREET

The west side of East Street where it meets Victoria Avenue looks very different today than the scene in this *c.* 1905 image. The church tower in the background, however, provides a degree of familiarity. Behind the horse and cart is the workshop of E. Kingsland, a saddler and harness maker.

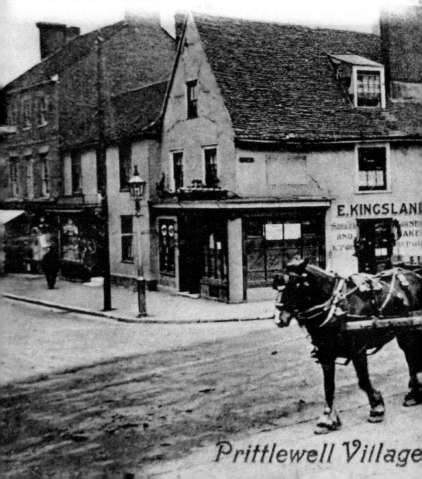

Prittlewell Village

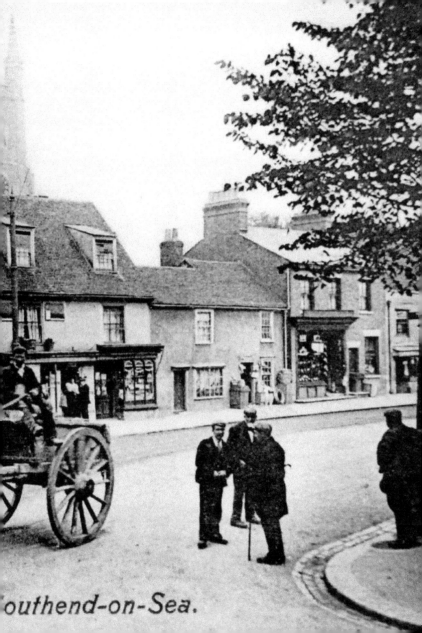

outhend-on-Sea.

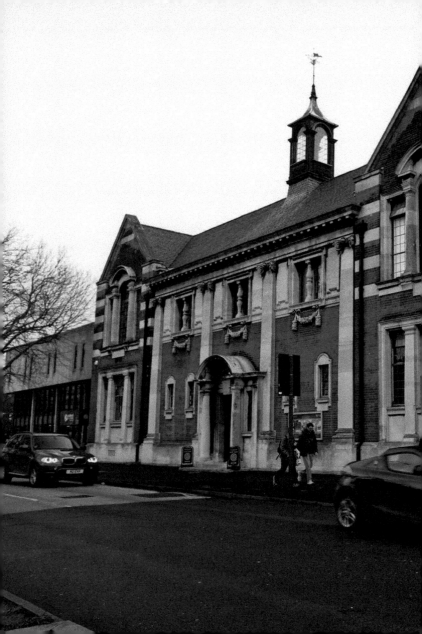

10. SOUTHEND MUSEUM

Made of red brick and Portland stone, this Grade II-listed building began life as a Free Library, receiving funding from Andrew Carnegie. Its foundation stone was laid down on 2 July 1905. Work was completed in 1906 and on Tuesday 24 July that year the library was officially opened by the publisher (and later Lord Mayor of London) Sir Horace Brookes-Marshall. The library later moved to a new purpose-built building next door and the old building was used to house Southend Central Museum. The building has its own planetarium.

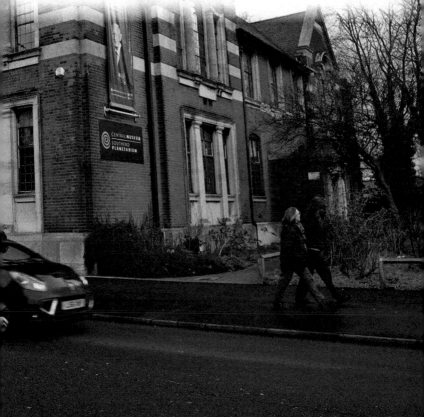

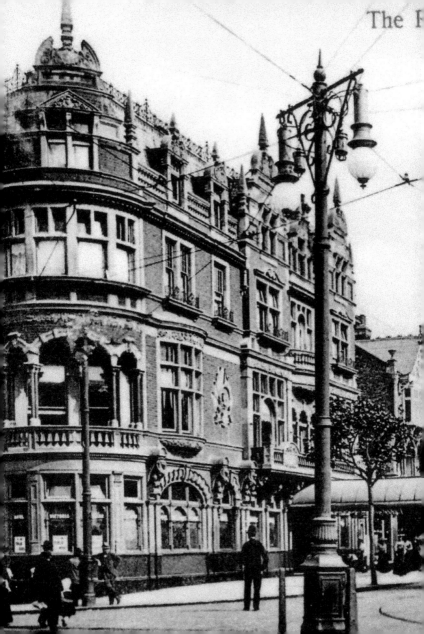

11. VICTORIA HOTEL

Built on the instructions of Philosopher John Burdett – that is the name with which he was baptized – the hotel began trading in 1898 with the porch extension completed in 1899. In 1939 the IRA used incendiary devices to set fires in seven hotels from Blackpool to Eastbourne, of which the Victoria Hotel was one. Ormonde Sheddon Broadhurst, at one-time proprietor of the hotel, won £10,000 by drawing the 1923 Epsom Derby winner Papyrus. The site is today occupied by bookmaker William Hill. WHSmith is opposite and on the site once occupied by Essex House.

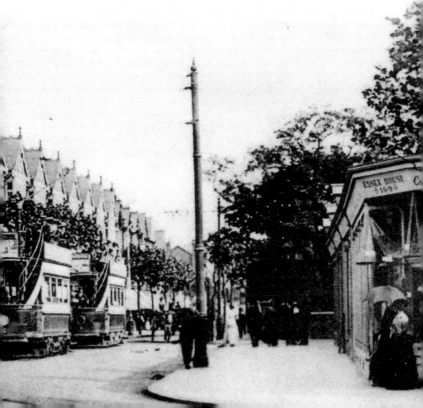

12. SOUTHEND HIGH STREET

This image shows Southend High Street looking north. The furthest building on the right-hand side of the High Street, near the trams, is the Victoria Hotel. Several of the buildings immediately south of the hotel still stand today.

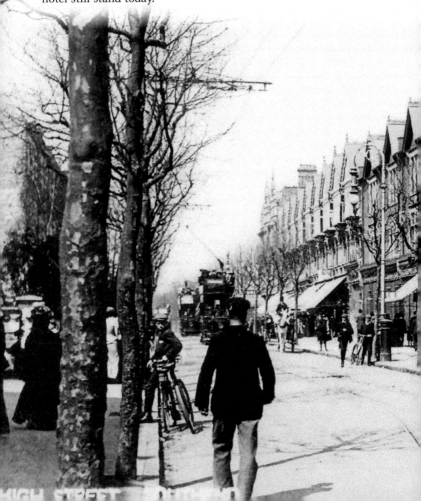

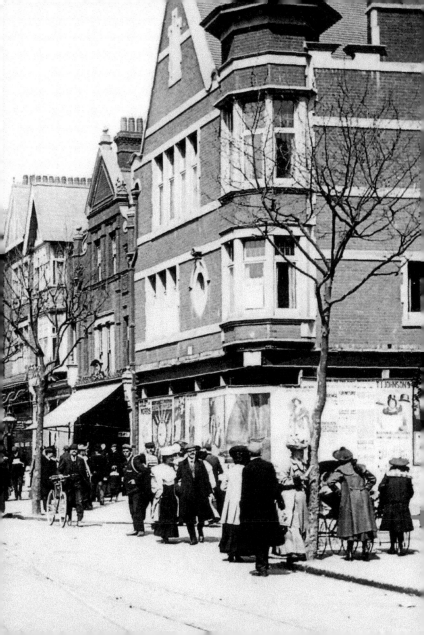

13. ROYAL TERRACE

This Georgian terrace, now known as Royal Terrace, was built in 1791–93. Its short-term occupants at Nos 7, 8 and 9 include Princess Caroline of Wales. A longer stay was had by the author Warwick Deeping (who has a memorial at St John the Baptist Church), who lived at the later built No. 19 in 1891.

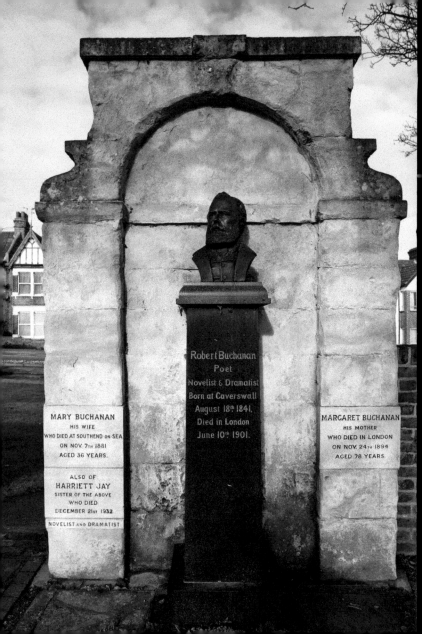

MARY BUCHANAN
HIS WIFE
WHO DIED AT SOUTHEND ON SEA
ON NOV. 7TH 1881
AGED 36 YEARS.

ALSO OF
HARRIETT JAY
SISTER OF THE ABOVE
WHO DIED
DECEMBER 21ST 1932

NOVELIST AND DRAMATIST

Robert Buchanan
Poet
Novelist & Dramatist
Born at Caverswall
August 18TH 1841.
Died in London
June 10TH 1901.

MARGARET BUCHANAN
HIS MOTHER
WHO DIED IN LONDON
ON NOV. 24TH 1894
AGED 78 YEARS.

14. ST JOHN THE BAPTIST CHURCH

The monument on the left is in celebration of the life of the poet Robert Williams Buchannan (1841–1901). It is at the north end of the grounds of the parish church of Southend, which is dedicated to St John the Baptist.

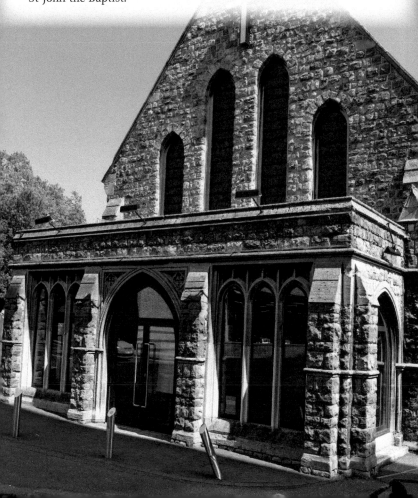

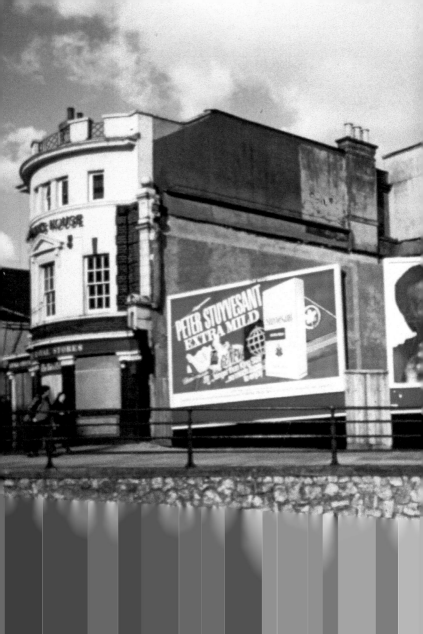

15. PIER HILL

This is the top of Pier Hill looking north-east, before these buildings were demolished to make way for the pedestrian area fronting the Royals Shopping Centre.

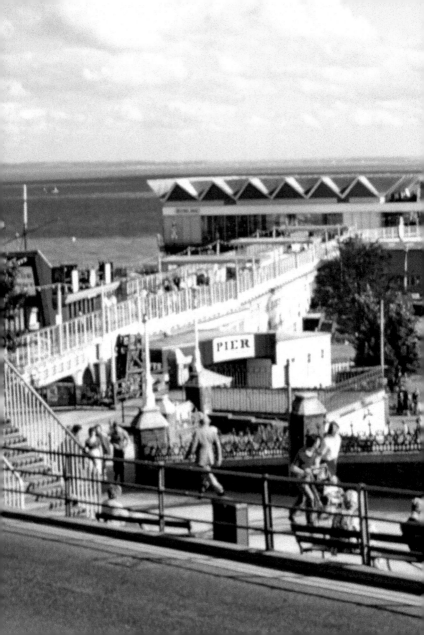

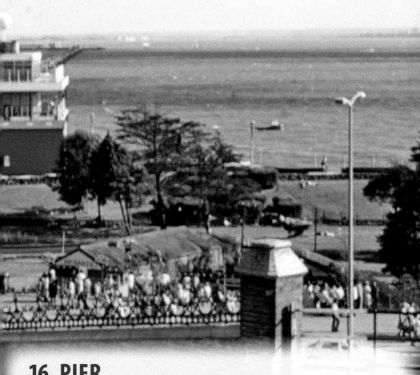

16. PIER

This view looks towards the Bowling Pavilion on the pier from the top of Pier Hill in 1980. Southend Pier was made of wood and was only 500 yards long when it first opened in 1830. Since then it has been extended several times and rebuilt. During the Second World War it was referred to as HMS *Leigh*. It is the longest pleasure pier in the world.

The pier looked very different in 1915 compared to 1980 and today. Note the clock just right of centre showing the time at twenty minutes past four.

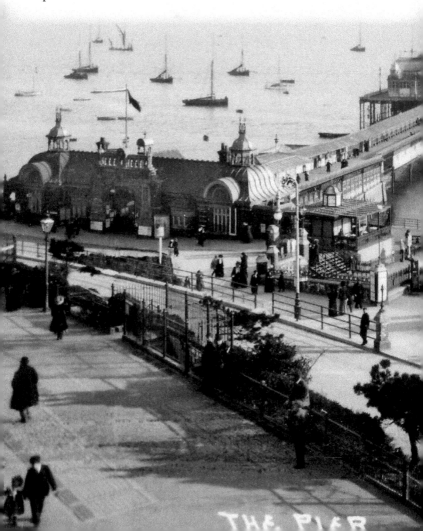

THE PIER

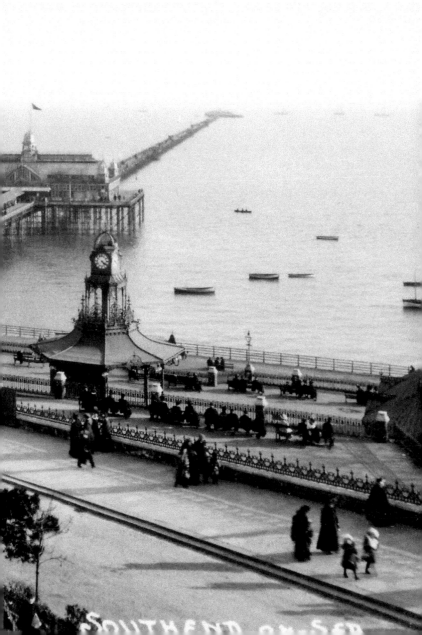

SOUTHEND ON SEA

17. ROYAL HOTEL

This pedestrian walkway from the seafront to the High Street is now open to cars. Right of centre is the Royal Hotel and to the left of that is Royal Terrace. Building on the Royal Hotel began in 1791 with the roof completed in early 1792. Note the Queen Victoria statue also on the right, which was moved to Clifftown Parade in 1962.

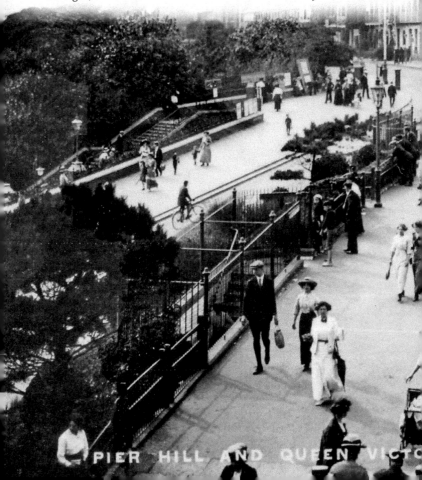

PIER HILL AND QUEEN VICTO

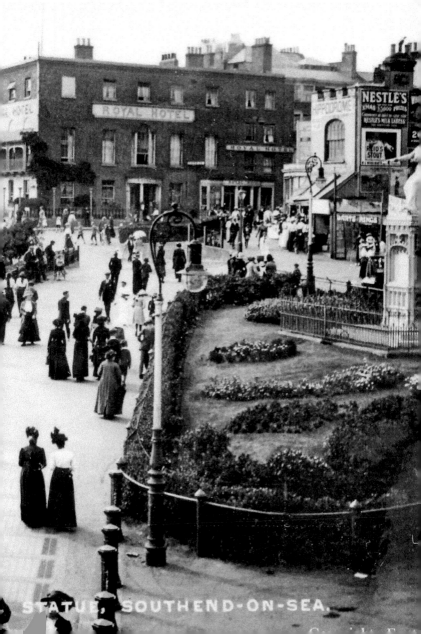

STATUE, SOUTHEND-ON-SEA.

18. TEA ROOM AND BATHS

The clock (see page 41) can also be seen in this picture, with the Royal Hotel in the background. The Pier Hill Tea Rooms can be seen on the left, with baths just below and to the right.

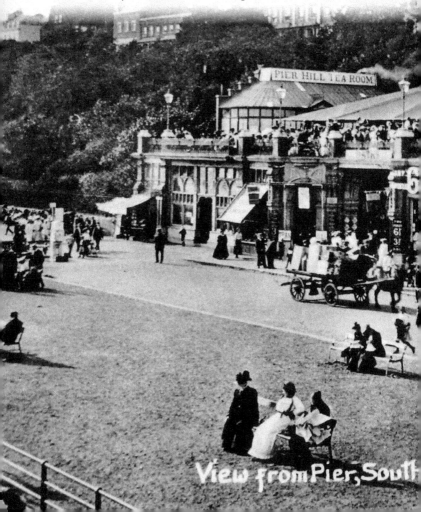

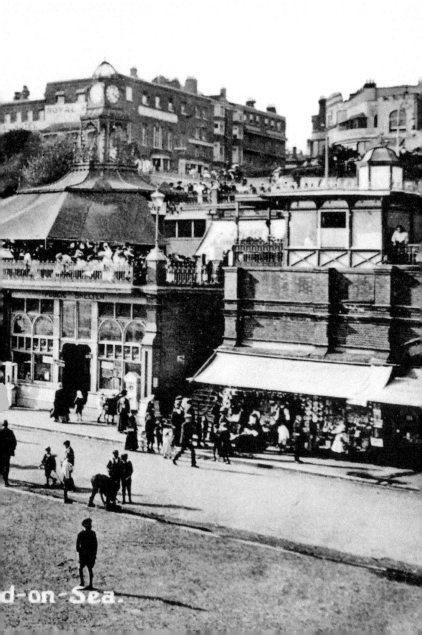

d-on-Sea.

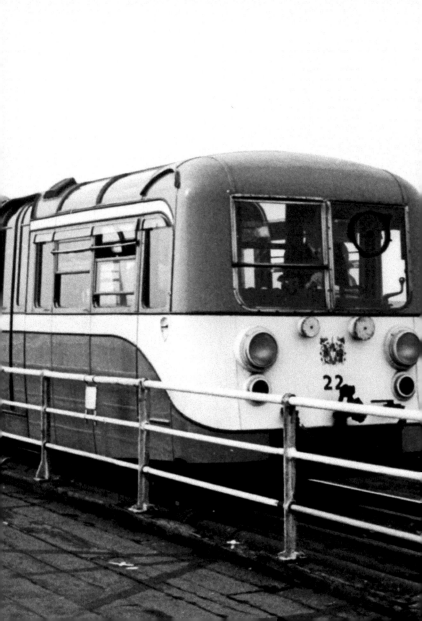

19. PIER TRAIN

You can walk to the end of the pier or travel by train. The pier train, as used in the 1970s, is more rounded and less streamlined than those used today. There is also a single-car pier train which carries the number 1835.

20. BOATING LAKE

The second sunken garden to be built is on the east side of the pier and was the home of the boating lake. There are people in the boats on the lake with onlookers relaxing in deckchairs. In the background is the pier bowling pavilion. The lake is no more. The sunken garden is now occupied by Adventure Island.

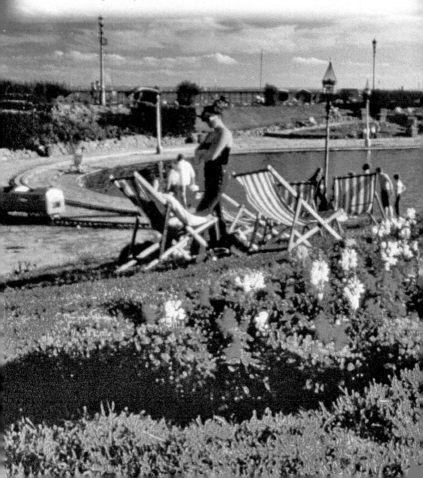

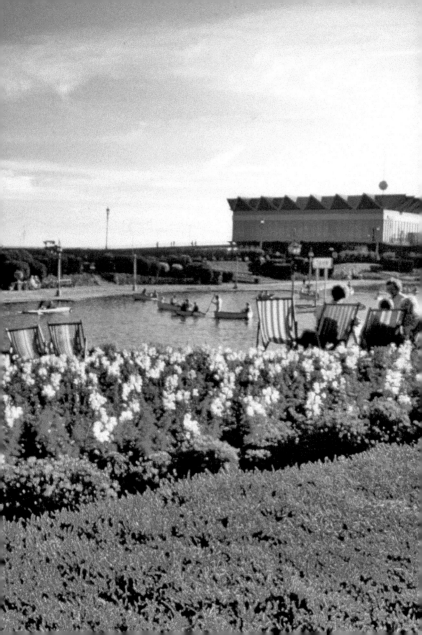

21. PETER PAN'S PLAYGROUND

Looking towards the Palace Hotel from the seafront, this is Peter Pan's Playground (1980) situated in the sunken garden on the west side of the pier and now occupied by Adventure Island. The 'Crooked House' is in the centre.

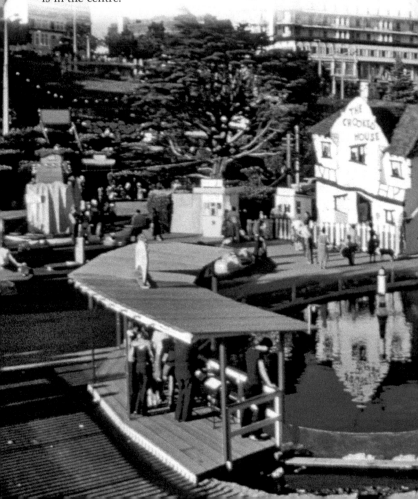

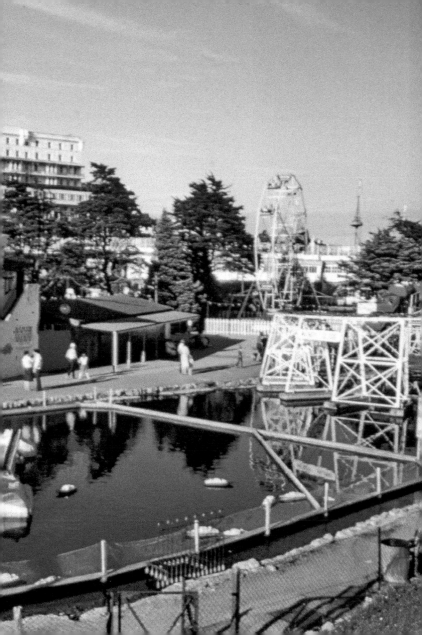

22. SUNKEN GARDENS

The first of the sunken gardens was built on the west side of the pier and was brought about mainly by the efforts of Alderman Albert Martin, who was mayor in 1902–03. The gardens housed the Royal Pier Pavilion.

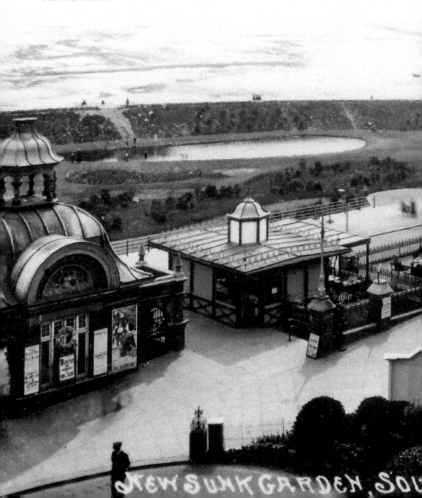

NEW SUNK GARDEN, SOU

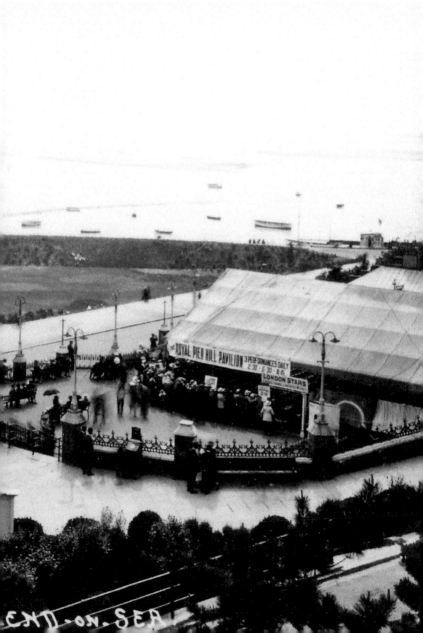

23. HOPE HOTEL

The Hope Hotel is a free house and one of the oldest surviving buildings on Southend seafront. The parts of the building without the balcony are a later addition.

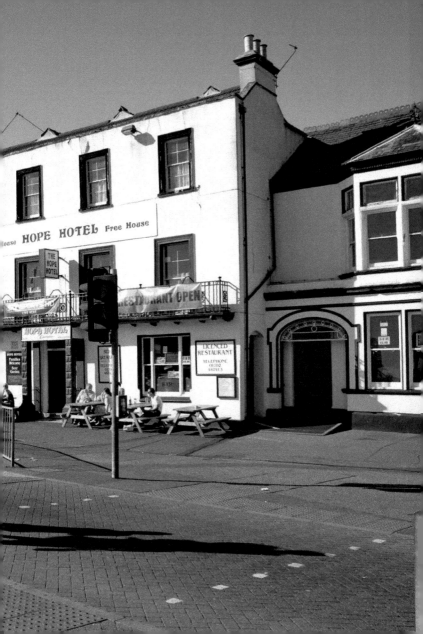

24. KURSAAL

The dome that sits above the Kursaal entrance is a familiar sight to returning Southend visitors. The Kursaal was opened on 24 July 1901 by Lord Claud Hamilton, chairman of Great Eastern Railways. A few days before, on 18 July, a tramline became operational, covering the 8 miles from the Kursaal to Leigh. On the left of this picture is Schofield Martin Stores, which was owned by Alderman Albert Martin.

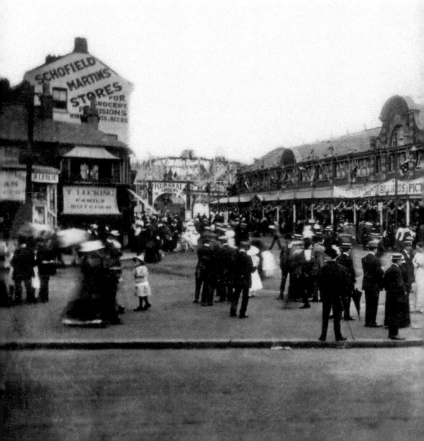

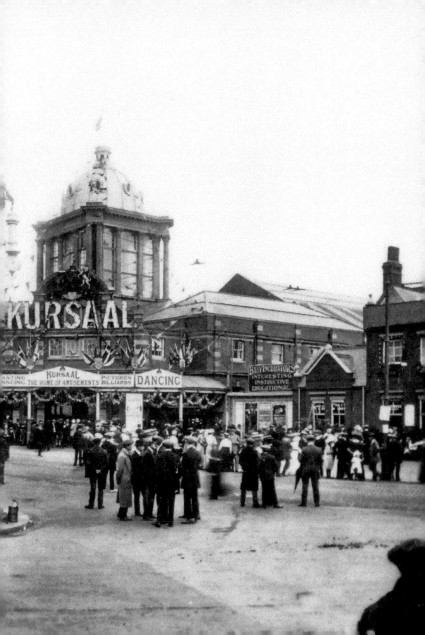

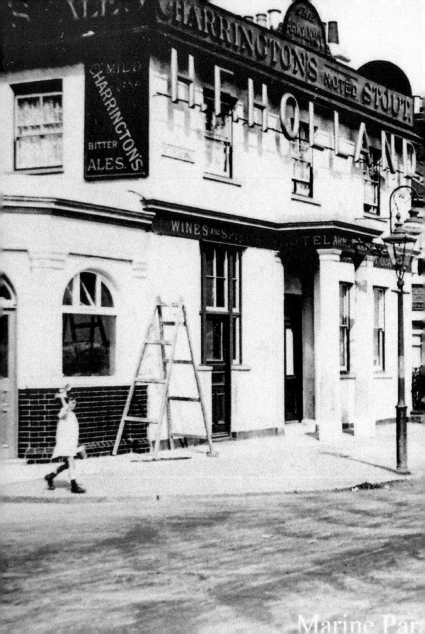

25. ARMY AND NAVY HOTEL

At the time this photograph was taken the proprietor was Henry Featherstone Holland. Henry was born in Hampshire, but before moving to Southend he was the proprietor of the Royal Hotel in Mile End. There he was vice chairman of the 'Royal' Music Society and he was a Freemason. His first wife, Kate, died in 1911. Henry married again in 1912. His second wife, Rebecca, survived him. Henry died in 1930. The building is now blue and white and is occupied by Atlantis. For those of you who have a copy of *Southend Through* Time, you will notice that in that book the building is red and white.

26. THE FUNICULAR RAILWAY

This 4-foot 6-inch gauge funicular railway is one of only a few in the country and is claimed to be the shortest. It enables passengers to travel from Western Esplanade to Clifftown Terrace. It was built in 1912, although the carriages have been replaced several times.

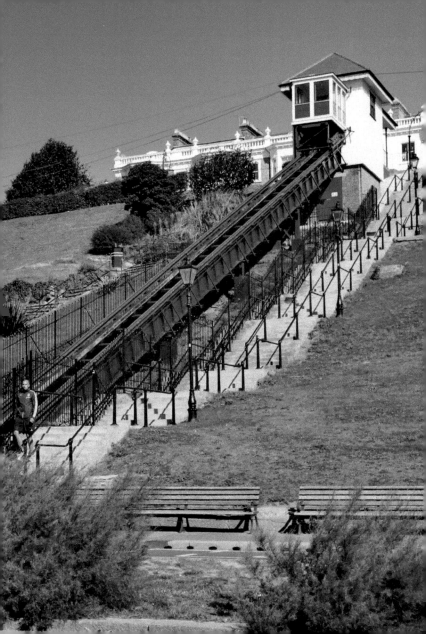

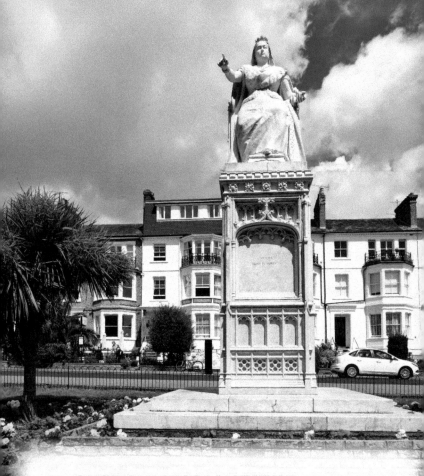

27. QUEEN VICTORIA STATUE

This Gothic-style statue of Queen Victoria once stood at the top of Pier Hill but was moved to Clifftown Parade in 1962. It was presented to the town by Mayor Bernard Wiltshire Tolhurst in 1897 and is made of Carrara marble, sourced from the town of that name in the Tuscany region of northern Italy.

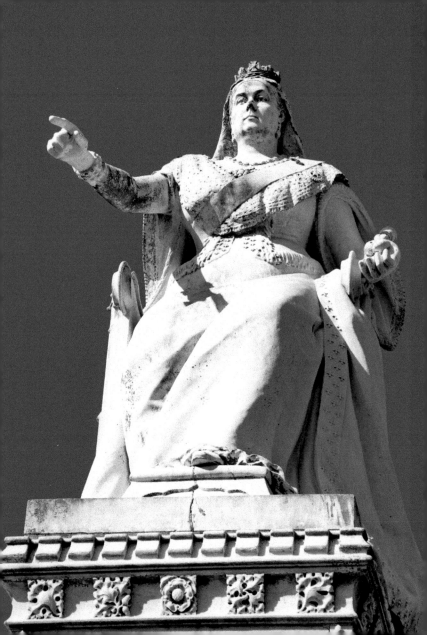

28. WAR MEMORIAL

Some 40 feet high and made of Portland stone, the Southend War Memorial was unveiled in 1921. It was designed by Sir Edwin Landseer Lutyens, who also designed the Cenotaph at Whitehall.

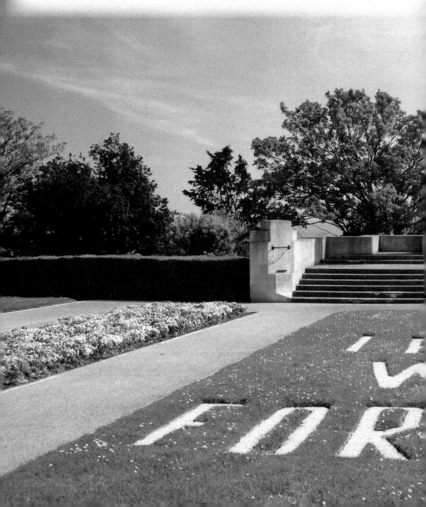

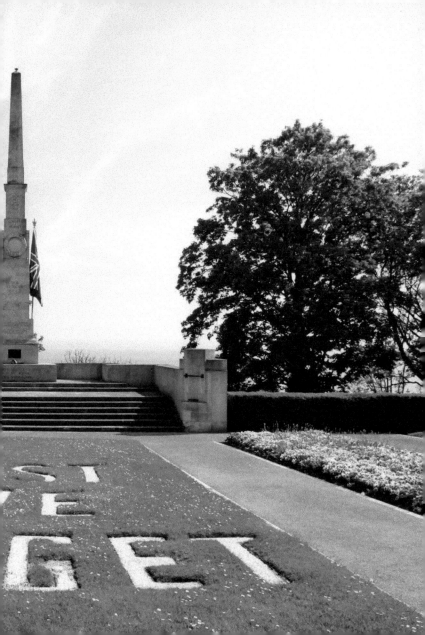

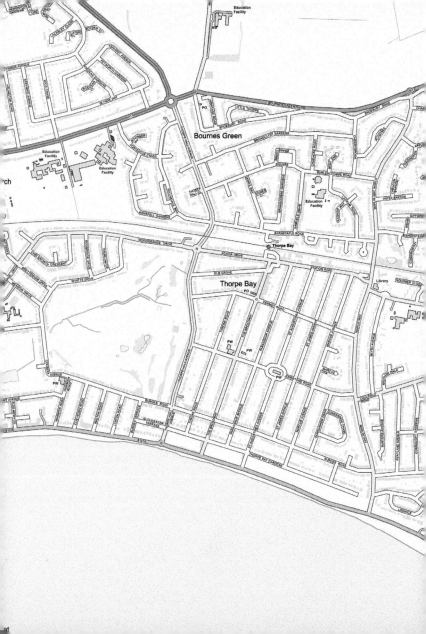

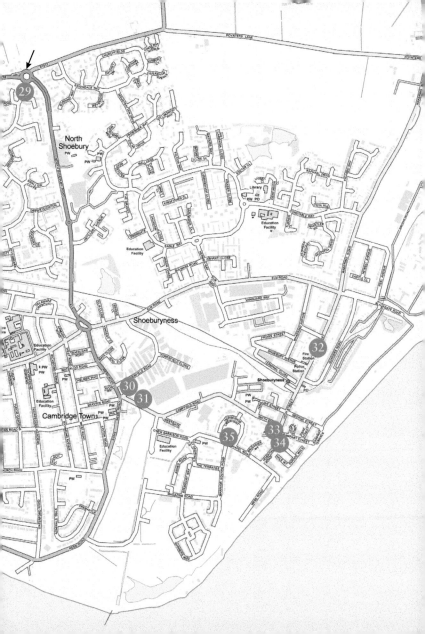

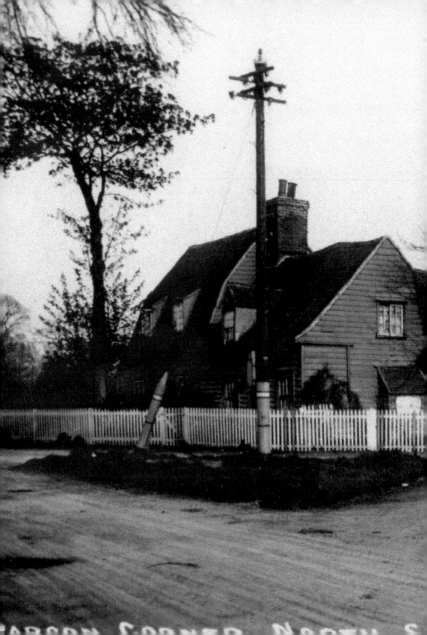

29. PARSONS CORNER

Parsons Corner was named after the Parson family who farmed in the area. Perhaps the best known of the family was Christopher Parson FLS. His wife's executors gave his natural history collection to the Southend Institute together with volumes of his compiled meteorological records. His collection is now held at the Southend Central Museum.

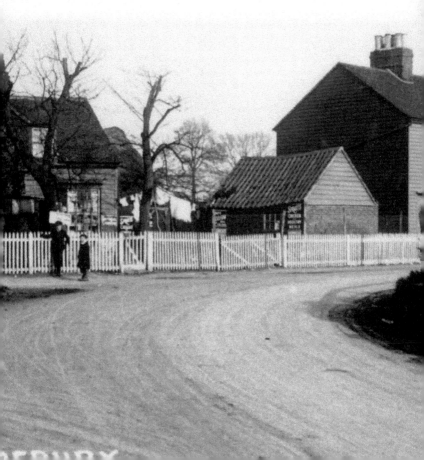

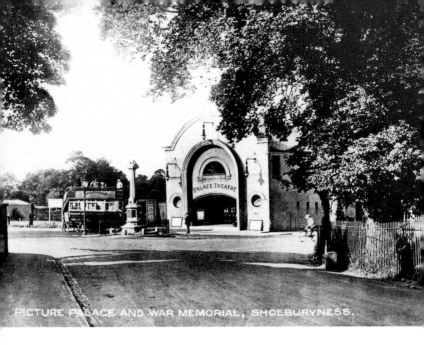

PICTURE PALACE AND WAR MEMORIAL, SHOEBURYNESS.

30. PALACE THEATRE

The Palace Theatre in Ness Road first opened its doors in 1913 but closed in 1955. The building, however, still stands. To the left of the theatre is the war memorial, which is made of Portland stone. It is no longer there, but has been moved further down Ness Road to Campfield Road.

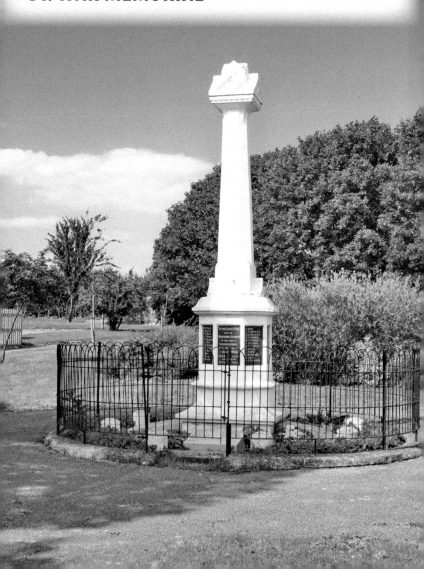

32. HIGH STREET WEDDING

This 1907 picture shows a carriage display in Shoebury High Street to celebrate the marriage of Lieutenant Strachan and Gladys Jocelyn, the daughter of Colonel Jocelyn. The two were married at St Nicholas' Church in Great Wakering. Gladys wore an empire gown made of ivory satin, with a train of lace on top of silk and chiffon. Also worn was a wreath of orange blossom covered with a veil.

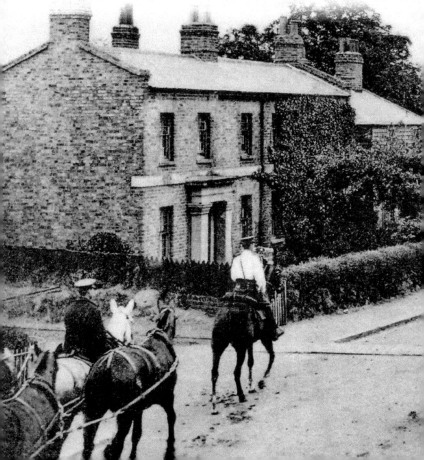

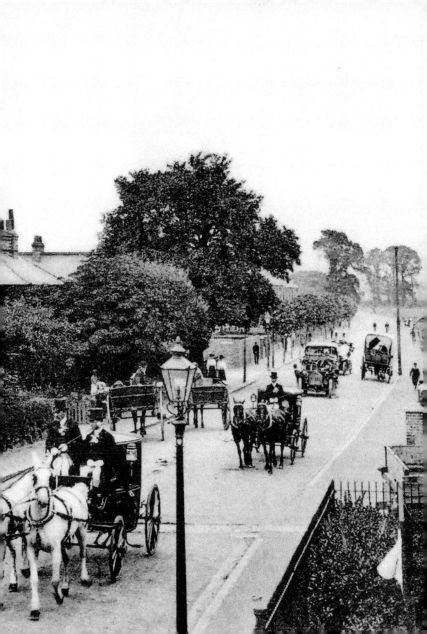

33. SHOEBURYNESS HOTEL

On the right is the Shoeburyness Hotel, also known as the Shoeburyness Tavern. In the mid- to late 1800s it was occupied by the Kirkwood family for around thirty years. At the time this photograph was taken (*c.* 1925), however, the occupier was Fred Desborough. Under his occupancy the tavern was a well-known training centre for the Ancient Order of Froth Blowers – a charitable organization whose activities were covered in the *Sporting Times*. Fred achieved the distinction of Grand Tornado for recruiting 100 members to the cause.

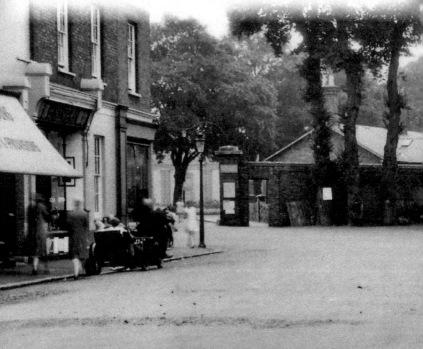

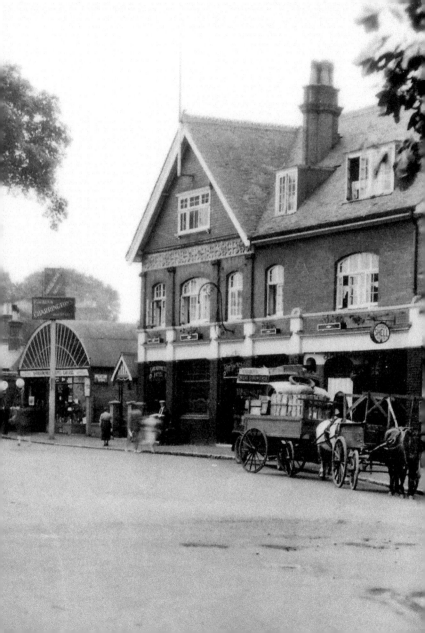

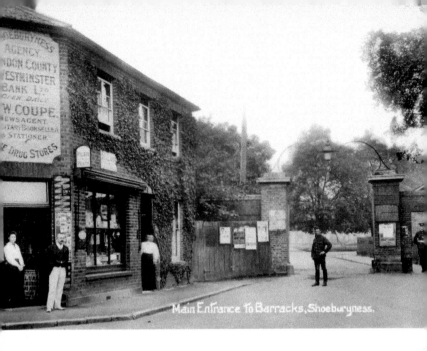

Main Entrance to Barracks, Shoeburyness.

34. BARRACK ENTRANCE

Born in Brentwood and the son of William Coupe, a chemist and postmaster, Shirley William Coupe traded from the building on the left as a newsagent, military bookseller and stationer. It is likely to be Shirley and his wife, Amelia, standing in the doorway. Shirley later lived in Westcliff. On the next page is a picture of the clock tower, which was once part of Horseshoe Barracks. Walk through the arch and you will see a cannon, which was restored in 2005.

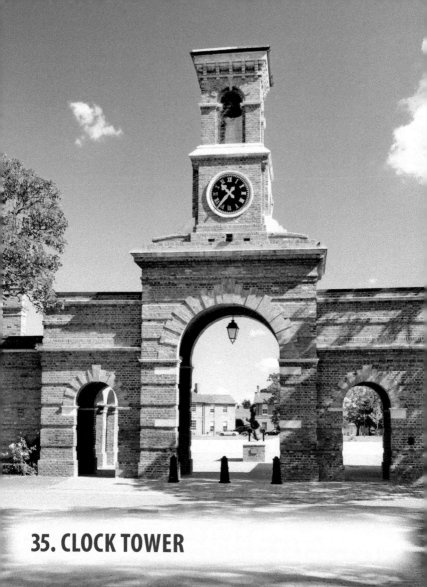

35. CLOCK TOWER

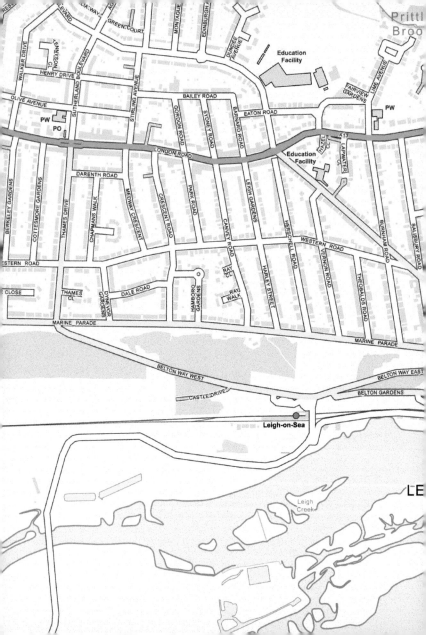

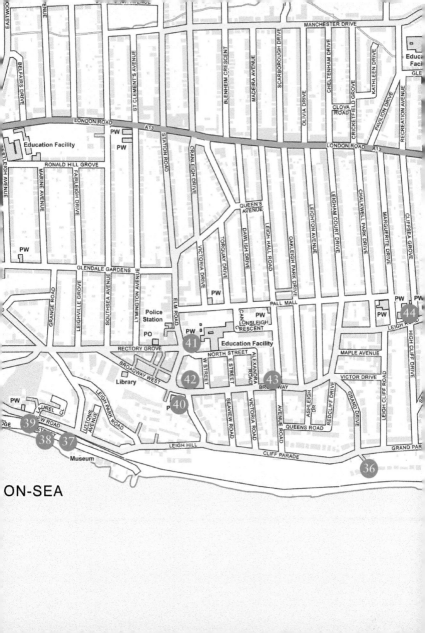

ON-SEA

36. ESSEX YACHT CLUB

The Essex Yacht Club was founded in 1890 and takes pride in having its headquarters on a ship. From 1894 to 1930 the club was aboard the *Gypsy*, seen here in around 1910. Today, it is HMS *Wilton*, a former Royal Navy minesweeper.

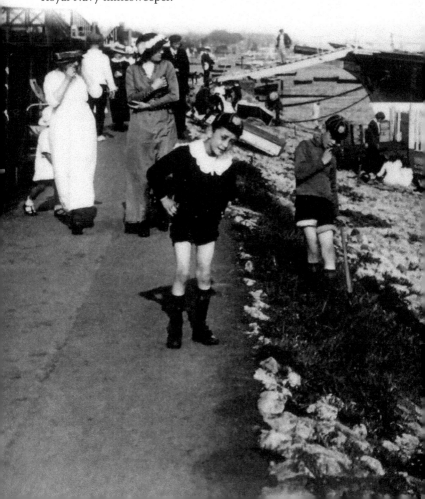

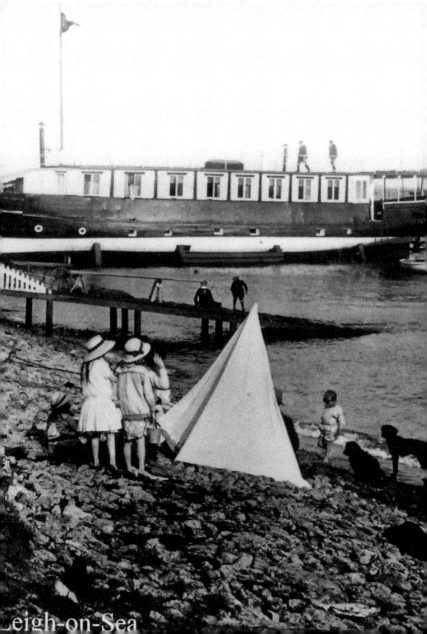

Leigh-on-Sea

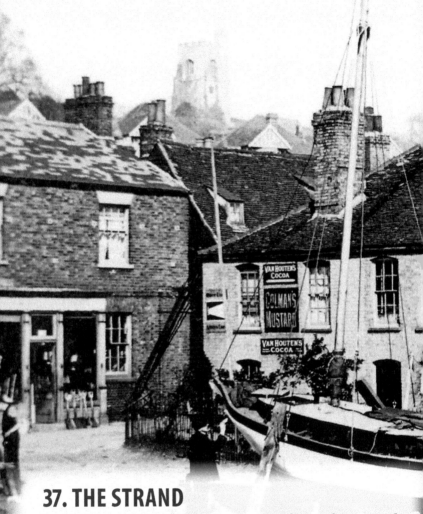

37. THE STRAND

In this image of The Strand taken in around 1915, the tower of St Clement's Church can be seen on the skyline. The house on the right was once occupied by Richard Chester, who was Master of the Corporation of Trinity House in 1615.

nd Leigh-on-Sea

38. HIGH STREET

On the left is the United Brethren Inn. At the time this photograph was taken (*c.* 1915) the licensee was E. P. Ball. In 1906 the licence was temporarily transferred to a Mr Rogers. The building still stands, but has a different function today. On the right the sign carries the name 'Crocer & Baker'.

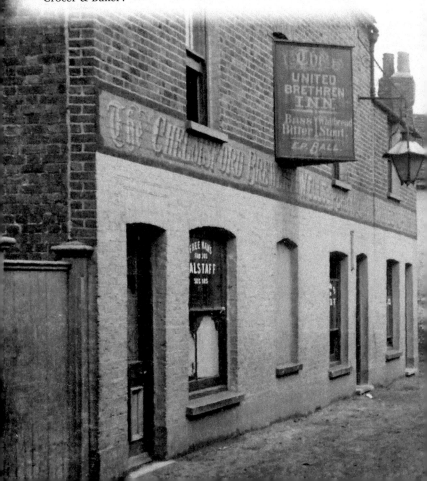

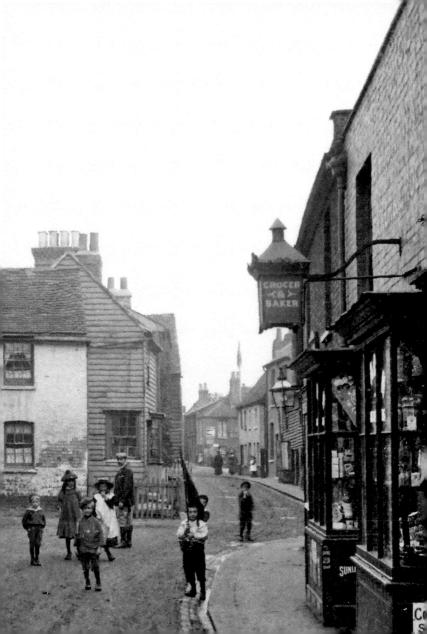

39. CROOKED BILLETT

On the west side of the High Street is the Crooked Billet, which still stands today. The building on its east side also still exists, although the windows on the second floor of that building do not. The building on the west side of the Crooked Billet has been demolished.

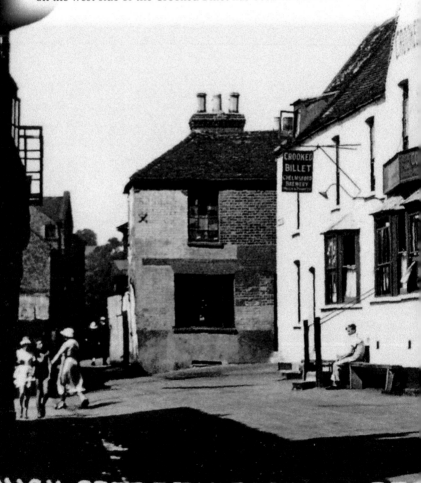

40. ST CLEMENT'S CHURCH

This church at the top of Leigh Hill is dedicated to St Clement. There has been a place of worship here since the thirteenth century, although the current church, which is built of Kent ragstone, dates from the late fourteenth or early fifteenth century. The tower was built a century or so later. The ivy was removed in the 1930s.

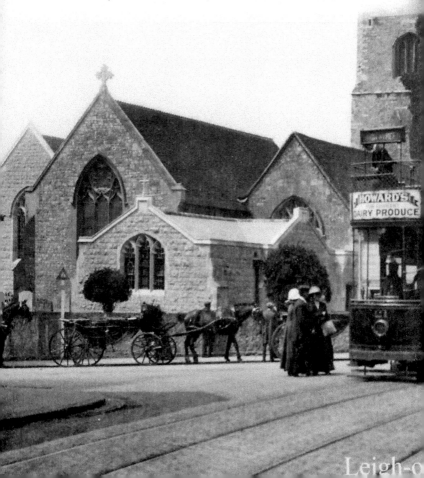

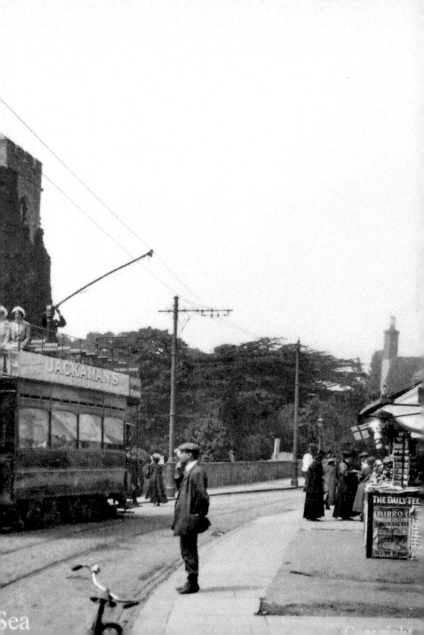

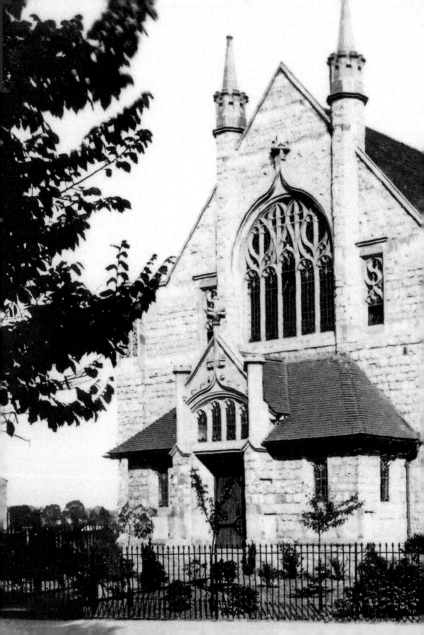

41. WESLEY CHURCH

John Wesley (1703–91), the energetic evangelist who founded Methodism, first visited Leigh in 1748. This church, which carries his name, is in Elm Road and was completed in 1897. The church looks the same today as it did in this *c.* 1915 image, except the railings and fence have been replaced by a low brick wall.

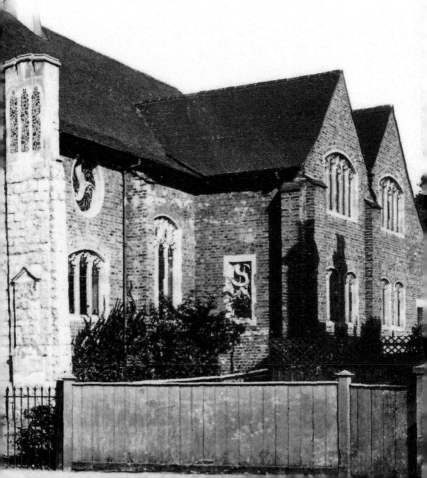

42. BROADWAY (WEST)

This image shows the west end of the Broadway as seen in *c*. 1925. The County Life newsagent building has been replaced. The tall building next to it remains. The No. 45 tram on the right carries the sign 'The one bright spot, the Kursaal, open all day including Sundays'.

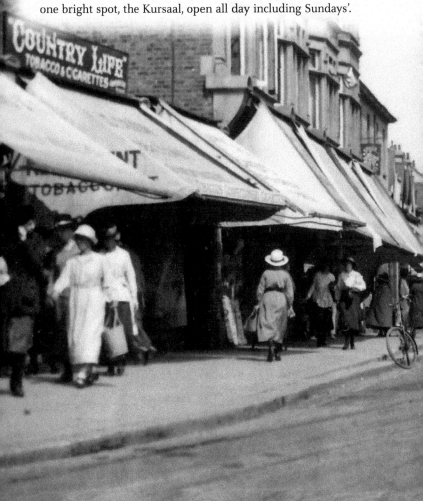

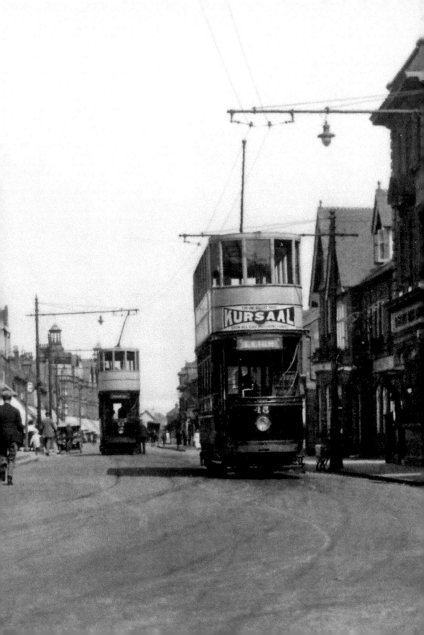

43. BROADWAY (EAST)

At the time this picture was taken A. S. Jenner, a coal merchant, occupied the building on the corner of Leigh Hall Road. Next door is T. N. Jordison, a greengrocer. He is probably the same Thomas North Jordison who was a farmer living in Rayleigh and who operated a furniture removal service. His son George Arthur Jordison also traded as a greengrocer in the Broadway. Next to Jordison is Leigh Bazaar, which was managed by John Dickinson until his death in 1910, then by his two daughters.

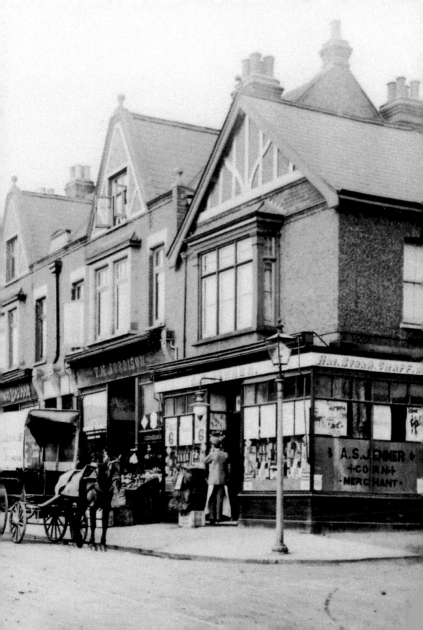

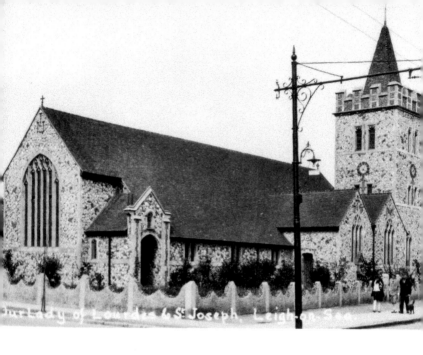

Our Lady of Lourdes & St Joseph, Leigh-on-Sea.

44. CATHOLIC CHURCH

The church dedicated to Our Lady of Lourdes and St Joseph was designed by Cannon Gilbert and consecrated by the Bishop of Brentwood. The foundation stone was laid in 1924 and the building was completed the following year. A weathervane sits at the top of the tower. This represents the fourteen-year-old peasant girl Bernadette Soubirous who, on 11 February 1858, had a vision of the Virgin Mary at Lourdes.